I dedicate *Color My Moods Adult Coloring Books and Journals* **Color Cl**

to my family and to all the wonderful colorists who bring my artwork to life!

- Maria Castro -

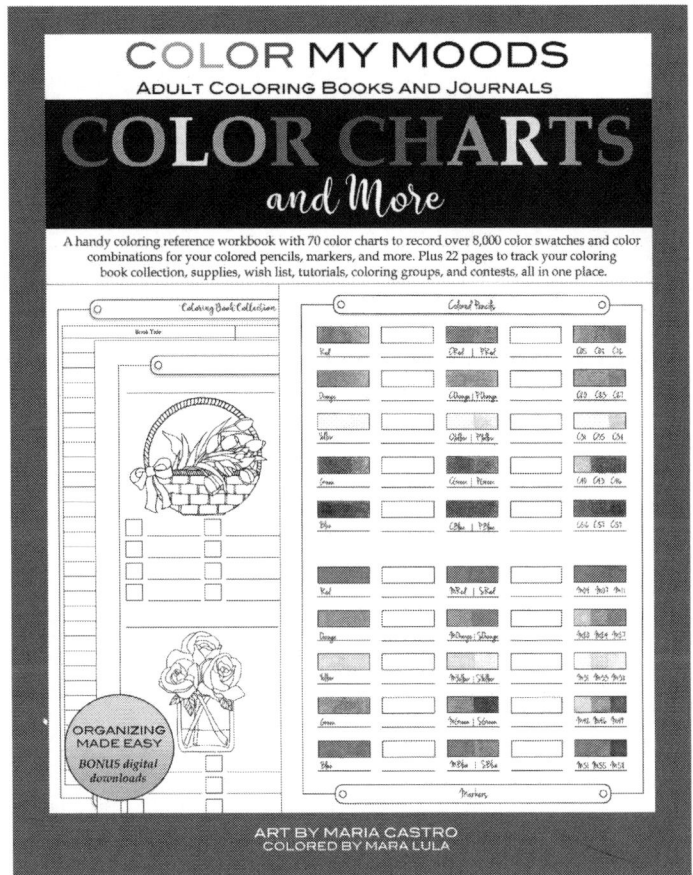

Special thanks to the colorists who shared their time and talent with us!

Front cover coloring:

Mara Lula

Mara Lula and *Jennifer Shaffer* for sharing their valuable feedback

Thank you for choosing *Color My Moods Adult Coloring Books and Journals* **Color Charts and More** to add to your coloring book collection! While *Color My Moods* **Color Charts and More** is not your typical "coloring" book, we can almost guarantee that it will be one of your favorites in your stash.

Think of *Color My Moods* **Color Charts and More** as your trusty best friend that can help keep your coloring life organized. Many of the coloring mediums have casings that do not reflect the actual color of the medium once used on paper. Creating color charts or color swatches is a great way to avoid those accidental use of the "wrong" color. But wait…how about your list of books, supplies, and more?

Don't worry. We got you covered. We divided the book into several sections keeping flexibility in mind:
- 50 color charts pages to create swatches for at least 2,500 colors or up to 7,500 colors if you choose to put 3 colors in one slot! Use the blank title spots on top or bottom to label your color chart.
- 4 color charts that can display 150 colors all on one page.
- 6 coloring pages where you can record your favorite mandala color combinations. Tip: You can divide the mandala into 2 or 4 sections to record several favorite combinations.
- 2 coloring pages featuring 8 different floral designs to record your favorite coloring combinations.
- 2 coloring pages for recording your favorite hair and skin tone color combinations.
- 2 coloring pages for showing your favorite patterns coloring combinations.
- 2 *My Favorite Blending Combinations* pages. Swatch up to four individual colors for your favorite blending combinations and see them all blended together.
- 2 *My Favorite Color Combinations* pages to record your favorite color combinations from a coloring page or a coloring book. Use the rectangle to record book information, or better yet, take a photo of your colored page and paste it on the book. Use the squares to color in and record colors you used.
- 2 *Coloring Supplies Inventory* pages to keep track of your current coloring supplies. That's 60 sets of coloring mediums!
- 4 *Coloring Book Collection* pages to keep an inventory of your books. That's 120 coloring books!
- 4 *Favorite Artists* pages to keep track of you favorites, including their website, Facebook, Instagram, Pinterest, Twitter, and other information. There's room for your top 24!
- 2 *Coloring Supplies Wish List* pages because collecting them is as much fun as using them.
- 2 *Coloring Books Wish List* pages because we know once you start coloring, you'll want to add more books to your collection.
- 2 *Coloring Tips and Tutorials* pages for a quick reference of all the coloring techniques you've learned from YouTube, and more.
- 2 pages to list your favorite coloring groups.
- 2 pages to list coloring challenges, contests, and giveaways.
- 2 pages to keep track of your work in progress (WIP) and see them through completion.

Single-sided (printing is on one side of the page only and the back side is blank), non-perforated, medium weight pages make it suitable for different media including colored pencils, markers, gel pens, pastels, crayons, and more. We recommend using the extra blank sheets provided as blotter pages to minimize bleed through.

If you love *Color My Moods Adult Coloring Books and Journals* **Color Charts and More**, check out our coloring books and coloring journals on Amazon and other fine online retailers: **https://www.scribocreative.com/products/**. Our product page will have video previews of all of the drawings in each book. We hope that you'll also take a minute to leave a review. We strive to give you a five-star experience with every purchase. If you would like to give us feedback directly, email us at **info@scribocreative.com**. For more coloring inspiration, freebies, and exclusive discounts, subscribe to our enews: **https://www.scribocreative.com/enews/**. Post your colored pages on social media with #scribocreative #colormymoods #mariacastro and you might just get a surprise from us. To connect with us, visit: **https://www.scribocreative.com/about/**.

Have a good-MOOD coloring day, every day!
Maria Castro of ScriboCreative.com

This book belongs to:

Art from COLOR MY MOODS Mandala Wood Carvings

Name	Individual	Blended		Name	Individual	Blended

Name	Individual	Blended		Name	Individual	Blended

My Favorite Blending Combinations

Name	Individual	Blended

Name	Individual	Blended

Name	Individual	Blended

Name	Individual	Blended

Name	Individual	Blended

Name	Individual	Blended

Name	Individual	Blended

Name	Individual	Blended

Name	Individual	Blended

Name	Individual	Blended

Name	Individual	Blended

Name	Individual	Blended

Name	Individual	Blended

Name	Individual	Blended

Coloring Supplies Inventory

Category	Name	Quantity	Notes

Coloring Supplies Inventory

Category	Name	Quantity	Notes

Coloring Book Collection

Book Title	Artist/Publisher

Coloring Book Collection

Book Title	Artist/Publisher

Coloring Book Collection

Book Title	Artist/Publisher

Coloring Book Collection

Book Title	Artist/Publisher

Favorite Artists

Artist's Name		Website	
Facebook		Instagram	
Pinterest		Twitter	
Others		Others	

Artist's Name		Website	
Facebook		Instagram	
Pinterest		Twitter	
Others		Others	

Artist's Name		Website	
Facebook		Instagram	
Pinterest		Twitter	
Others		Others	

Artist's Name		Website	
Facebook		Instagram	
Pinterest		Twitter	
Others		Others	

Artist's Name		Website	
Facebook		Instagram	
Pinterest		Twitter	
Others		Others	

Artist's Name		Website	
Facebook		Instagram	
Pinterest		Twitter	
Others		Others	

Favorite Artists

Artist's Name		Website	
Facebook		Instagram	
Pinterest		Twitter	
Others		Others	
Artist's Name		Website	
Facebook		Instagram	
Pinterest		Twitter	
Others		Others	
Artist's Name		Website	
Facebook		Instagram	
Pinterest		Twitter	
Others		Others	
Artist's Name		Website	
Facebook		Instagram	
Pinterest		Twitter	
Others		Others	
Artist's Name		Website	
Facebook		Instagram	
Pinterest		Twitter	
Others		Others	
Artist's Name		Website	
Facebook		Instagram	
Pinterest		Twitter	
Others		Others	

Favorite Artists

Artist's Name		Website	
Facebook		Instagram	
Pinterest		Twitter	
Others		Others	
Artist's Name		Website	
Facebook		Instagram	
Pinterest		Twitter	
Others		Others	
Artist's Name		Website	
Facebook		Instagram	
Pinterest		Twitter	
Others		Others	
Artist's Name		Website	
Facebook		Instagram	
Pinterest		Twitter	
Others		Others	
Artist's Name		Website	
Facebook		Instagram	
Pinterest		Twitter	
Others		Others	
Artist's Name		Website	
Facebook		Instagram	
Pinterest		Twitter	
Others		Others	

Favorite Artists

Artist's Name		Website	
Facebook		Instagram	
Pinterest		Twitter	
Others		Others	
Artist's Name		Website	
Facebook		Instagram	
Pinterest		Twitter	
Others		Others	
Artist's Name		Website	
Facebook		Instagram	
Pinterest		Twitter	
Others		Others	
Artist's Name		Website	
Facebook		Instagram	
Pinterest		Twitter	
Others		Others	
Artist's Name		Website	
Facebook		Instagram	
Pinterest		Twitter	
Others		Others	
Artist's Name		Website	
Facebook		Instagram	
Pinterest		Twitter	
Others		Others	

Coloring Supplies Wish List

Category	Name	Quantity	Price	Notes

Coloring Supplies Wish List

Category	Name	Quantity	Price	Notes

Coloring Books Wish List

Artist's Name	Book Title	Release Date	Price	Notes

Coloring Books Wish List

Coloring Books Wish List

Artist's Name	Book Title	Release Date	Price	Notes

Topic	Source
Notes	

Topic	Source
Notes	

Topic	Source
Notes	

Topic	Source
Notes	

Topic	Source
Notes	

Topic	Source
Notes	

Topic	Source
Notes	

Topic	Source
Notes	

Topic	Source
Notes	

Topic	Source
Notes	

Coloring Tips and Tutorials

Topic	Source
Notes	

Topic	Source
Notes	

Topic	Source
Notes	

Topic	Source
Notes	

Topic	Source
Notes	

Topic	Source
Notes	

Topic	Source
Notes	

Topic	Source
Notes	

Topic	Source
Notes	

Topic	Source
Notes	

Coloring Groups

Group Name	Join Date	Notes

Coloring Groups

Group Name	Join Date	Notes

Coloring Contests

Due Date	Contest/Challenge Name	Rules	Prize	Notes

Coloring Contests

Due Date	Contest/Challenge Name	Rules	Prize	Notes

Work in Progress (WIP)

Start Date	Book	Notes	Completion Date

Work in Progress (WIP)

Start Date	Book	Notes	Completion Date

Bonus!

Go to: https://www.scribocreative.com/colorchartsbonus/ for your bonus digital downloads.
Use password **more**

Have a good-MOOD coloring day, everyday!

Printed in Great Britain
by Amazon